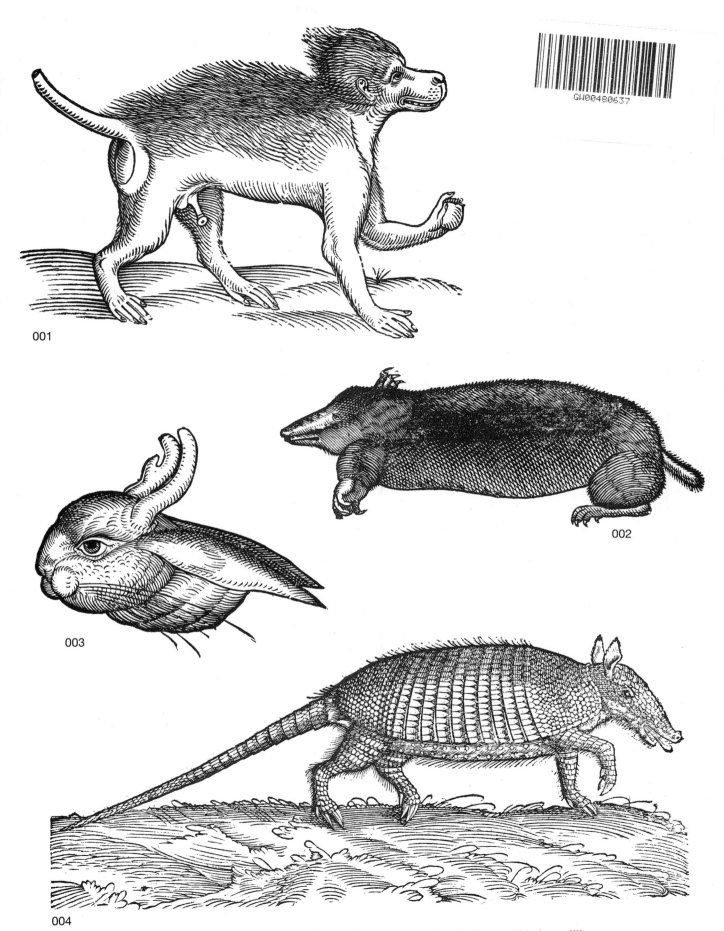

001

002

003

004

001. Baboon. 002. Mole. 003. A horned hare reputed to live in Saxony. 004. Armadillo.

GW00480637

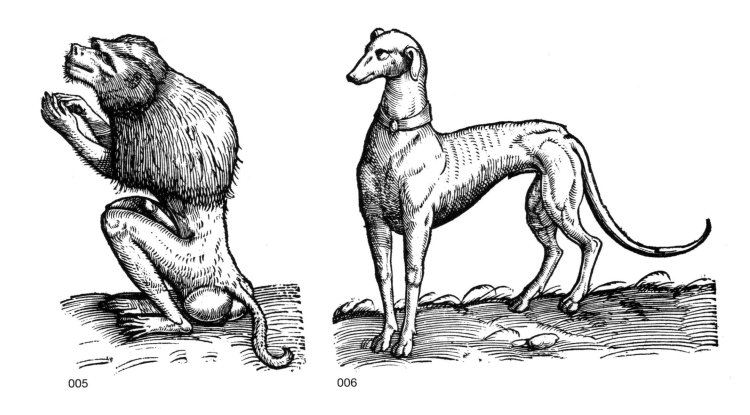

005

006

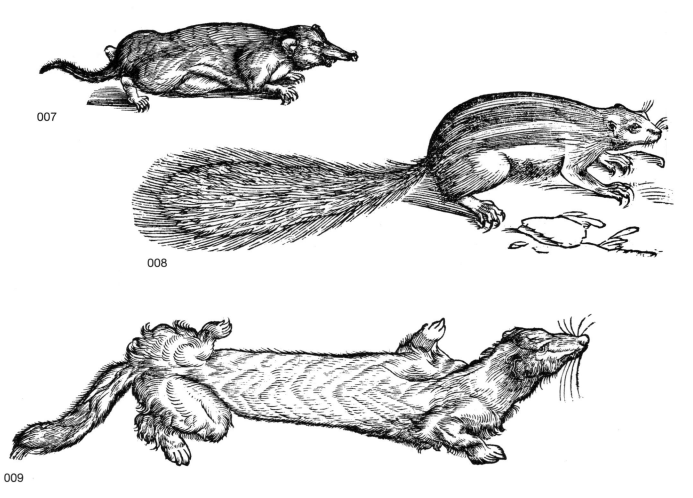

007

008

009

005. Another baboon or mandrill. 006. Greyhound. 007. Shrew. 008. Squirrel. 009. An Italian weasel.

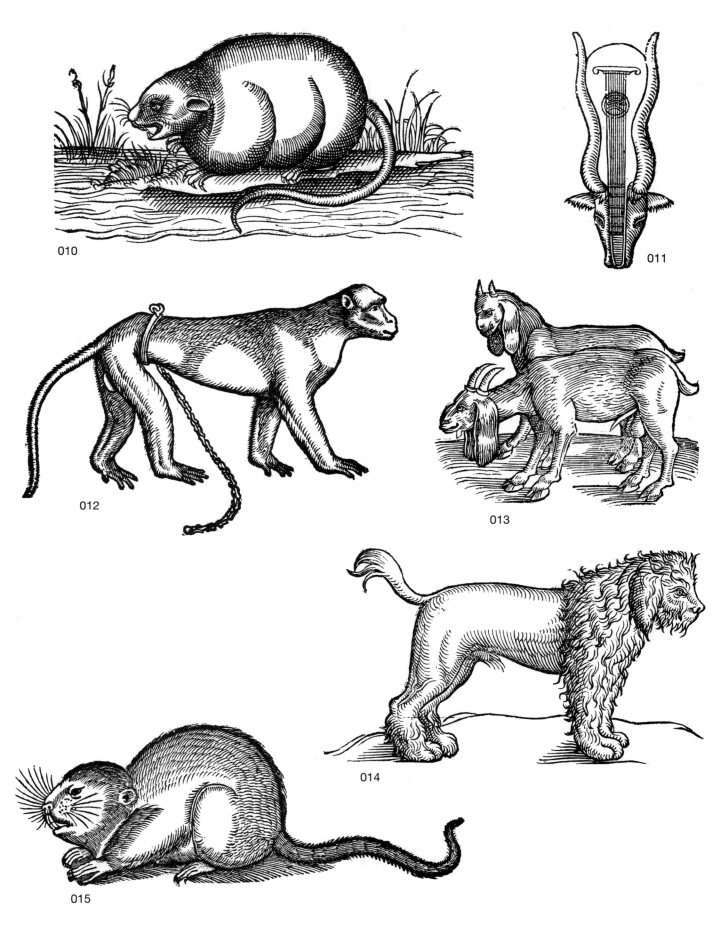

010 011 012 013 014 015

010. River rat. 011. Head of a Cretan sheep with a stringed instrument drawn in to show the curve of the horns. 012. A long-tailed monkey. 013. Indian goat. 014. Water spaniel (ancestor of the poodle). 015. Wild rat.

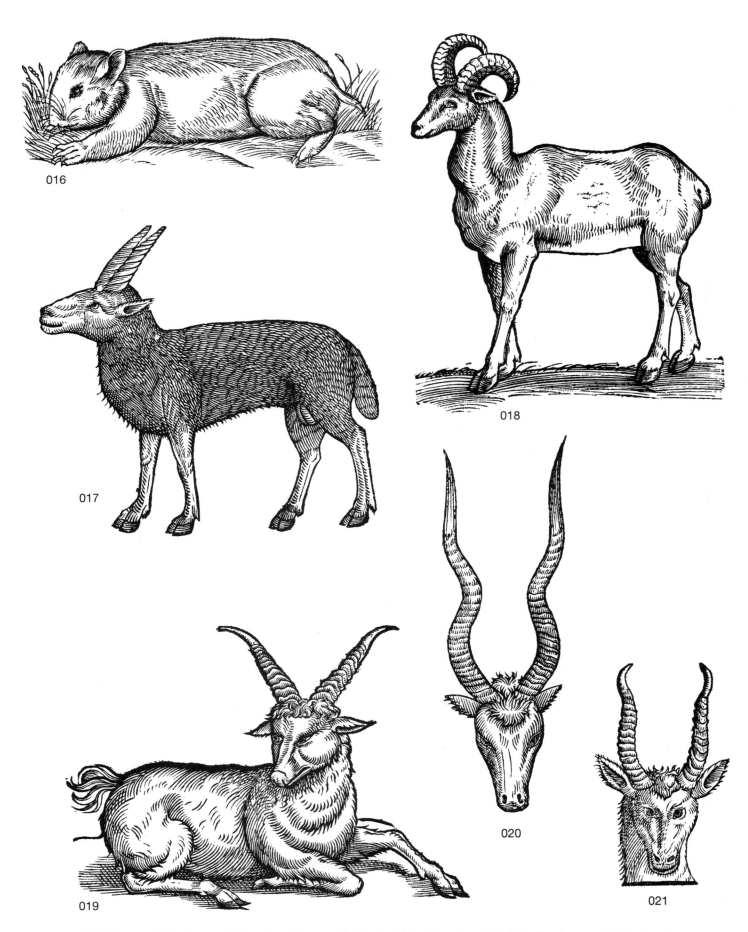

016. Hamster. 017. A type of sheep from Crete, probably the Walachian sheep. 018. Mouflon (a type of wild sheep).
019. Saiga (a sheep-like antelope of Central Asia). 020. Head of Cretan sheep. 021. Head of saiga.

4

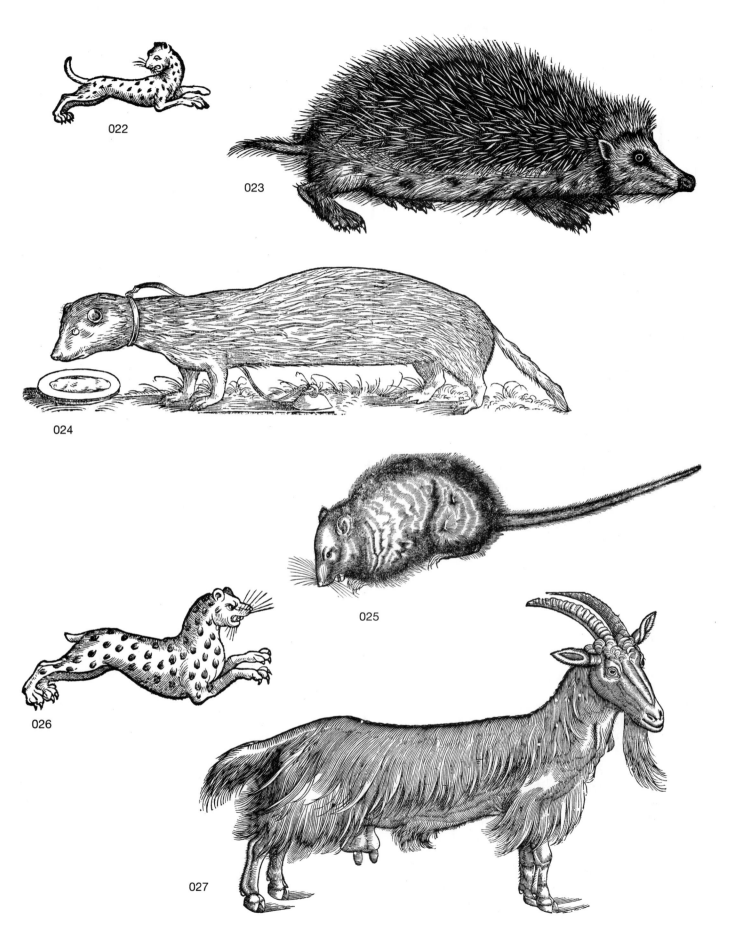

022 and 026. Wild cat. 023. Hedgehog. 024. Ferret. 025. Rat. 027. Domestic goat (nanny).

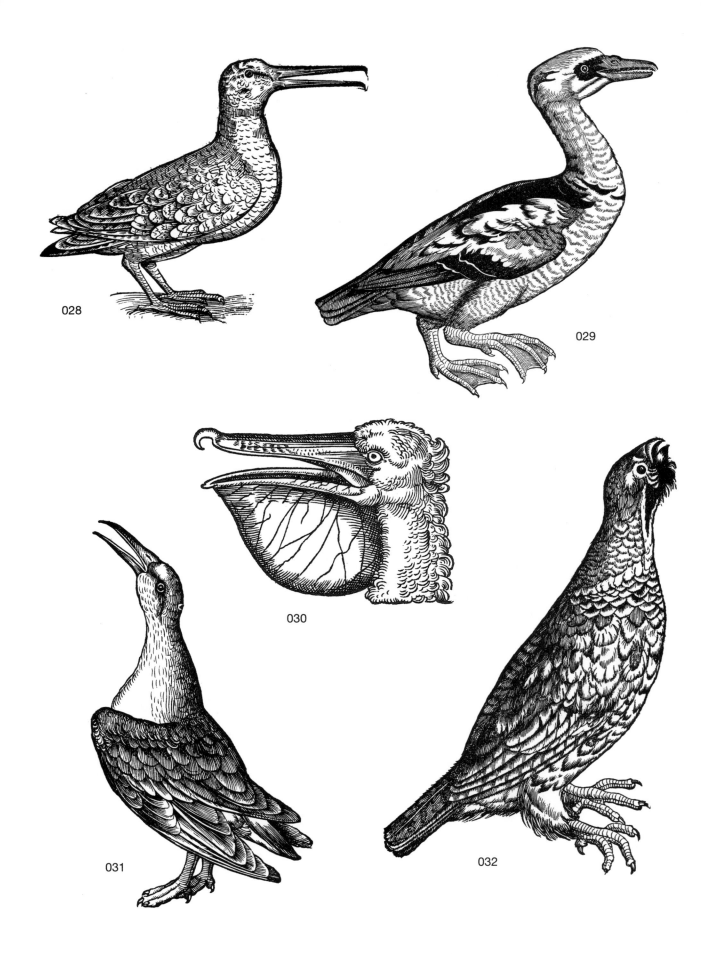

028. Snipe or woodcock. 029. Smew (a fish-eating duck). 030. Head of a pelican.
031. A shore bird, perhaps the dunlin (German, *Rotknillis*). 032. Hazel hen.

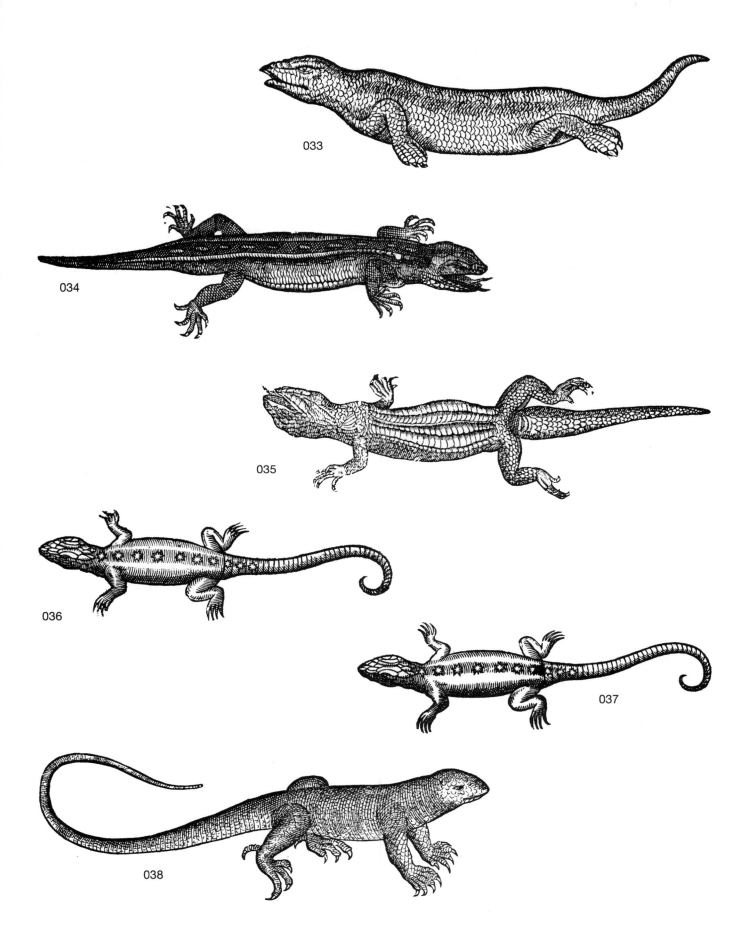

033. Skink. 034. A type of lizard. 035. A type of lizard (shown belly up).
036 and 037. Stellions (a type of lizard). 038. A Brazilian land lizard.

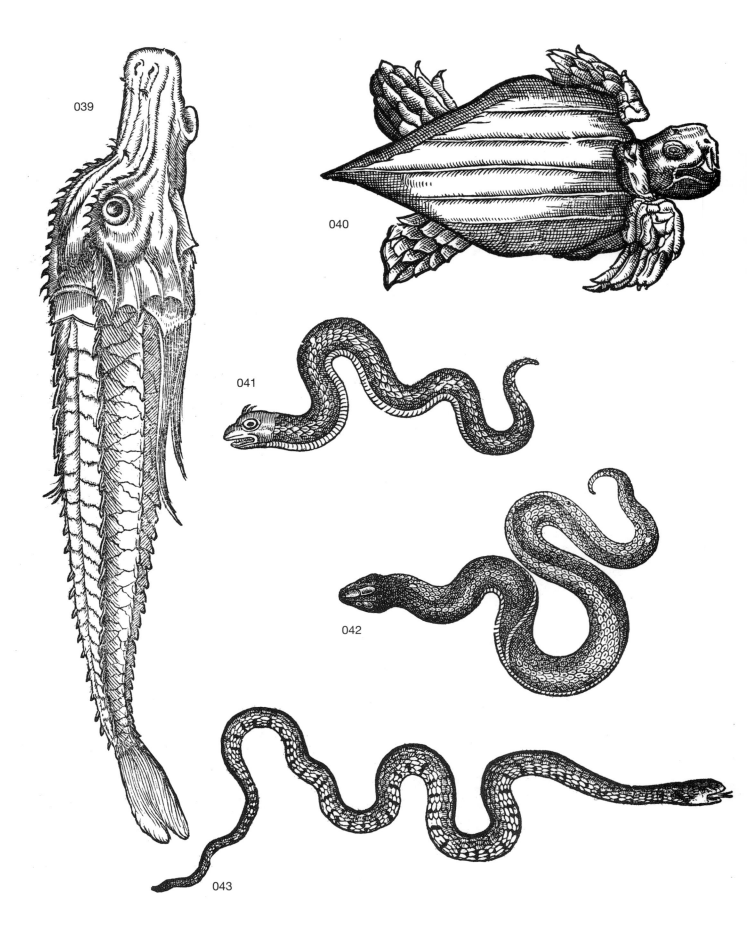

039. "Lamprey." 040. Leatherback turtle. 041. "Horned serpent" or cerastes.
042. "Millet" or "cenchrine" (a type of snake). 043. "Water adder."

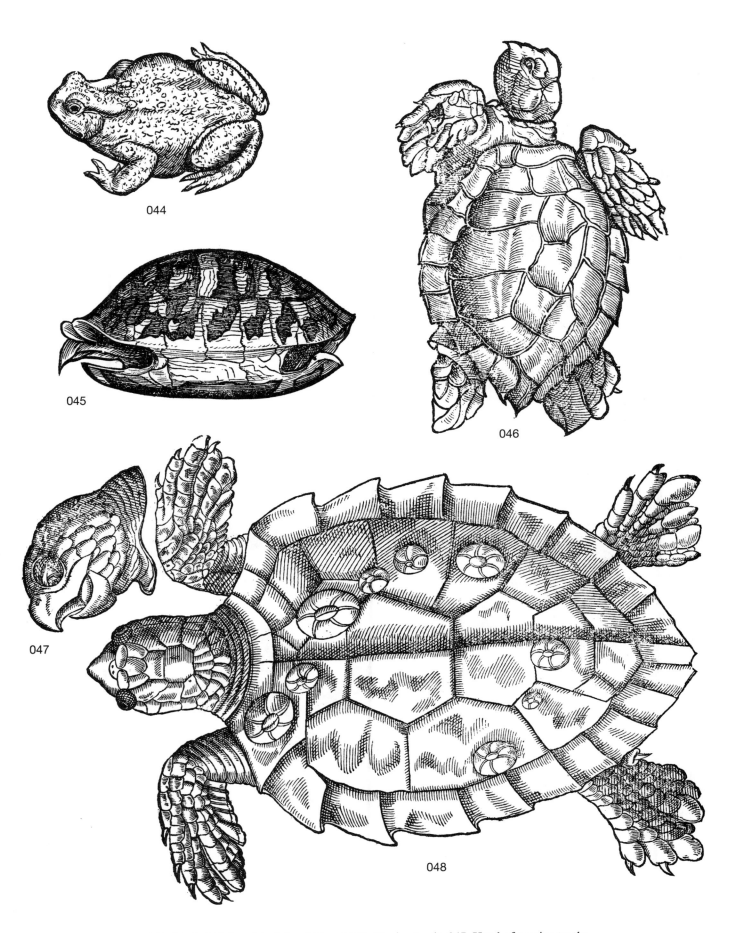

044. Toad. 045. Land tortoise. 046 and 048. Marine turtle. 047. Head of marine turtle.

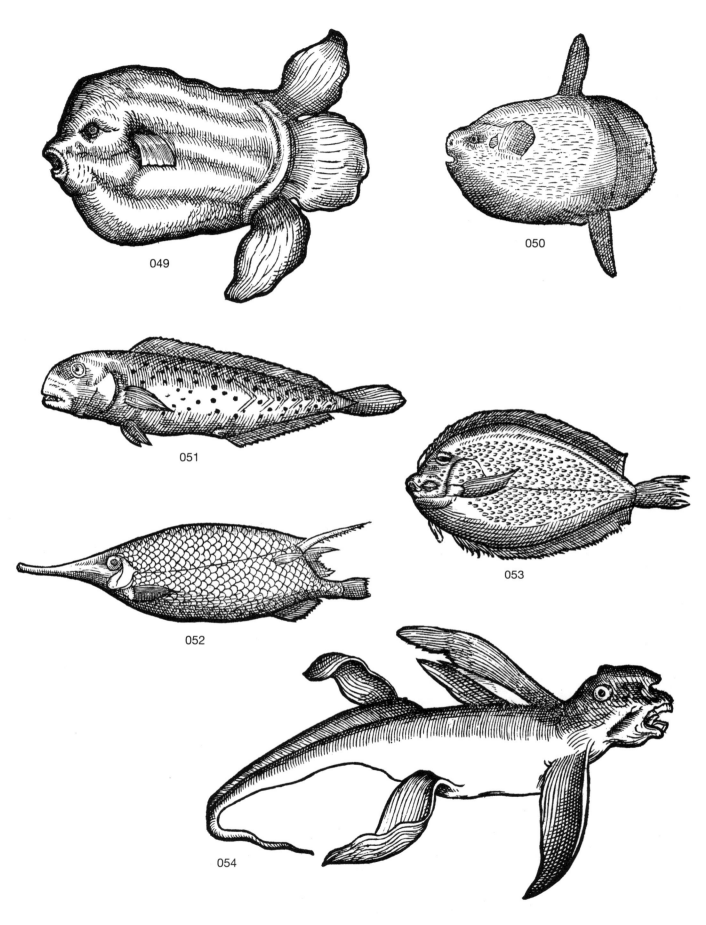

049 and 050. Sunfish. 051. Shanny or blenny. 052. Snipe fish or trumpet-fish.
053. A type of flatfish. 054. Elephant fish or chimaera.

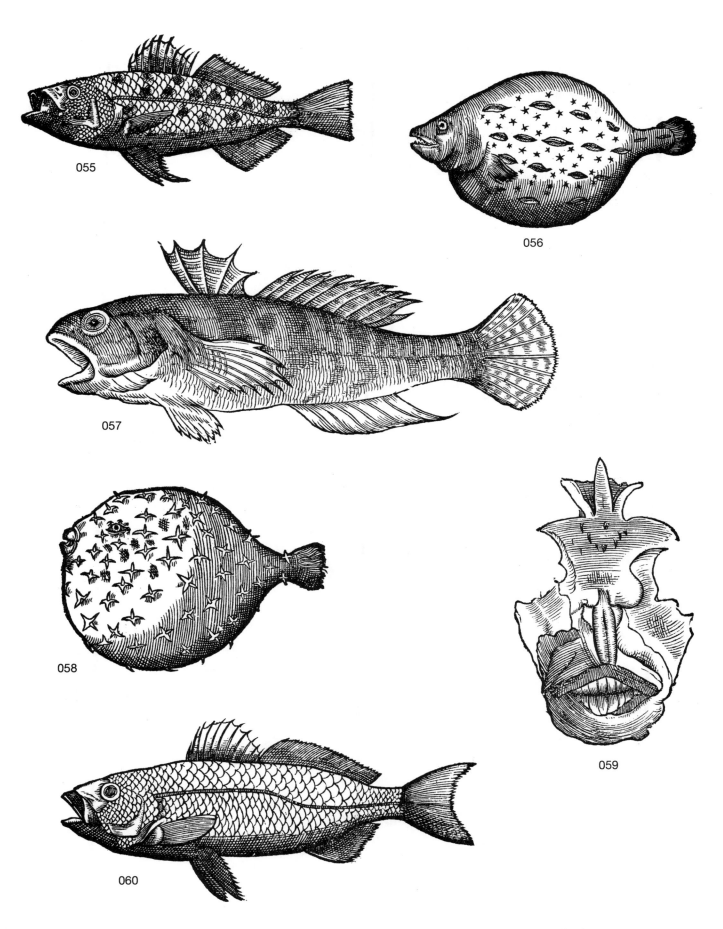

055 and 060. Sea perch or dace (French, *loup*). 056 and 058. Lumpfish. 057. A type of goby.
059. Head of sargo (kin of the American sheepshead).

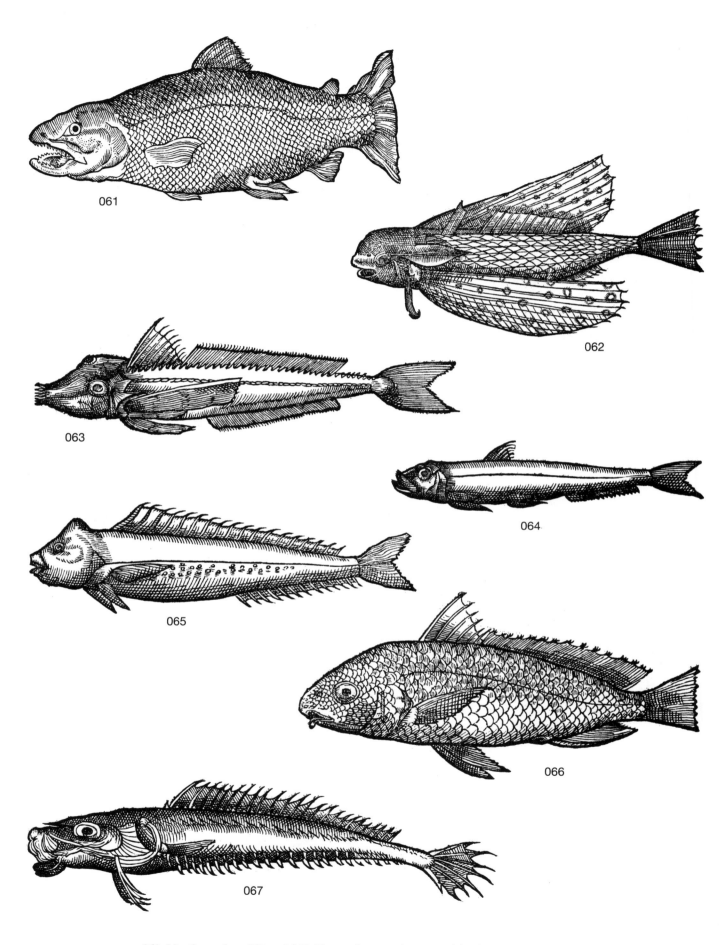

061. Northern char. 062 and 063. Types of gurnard or sea robin. 064. A type of goby.
065. A type of blenny. 066. Umbra. 067. An unidentified fish *(taenia)*.

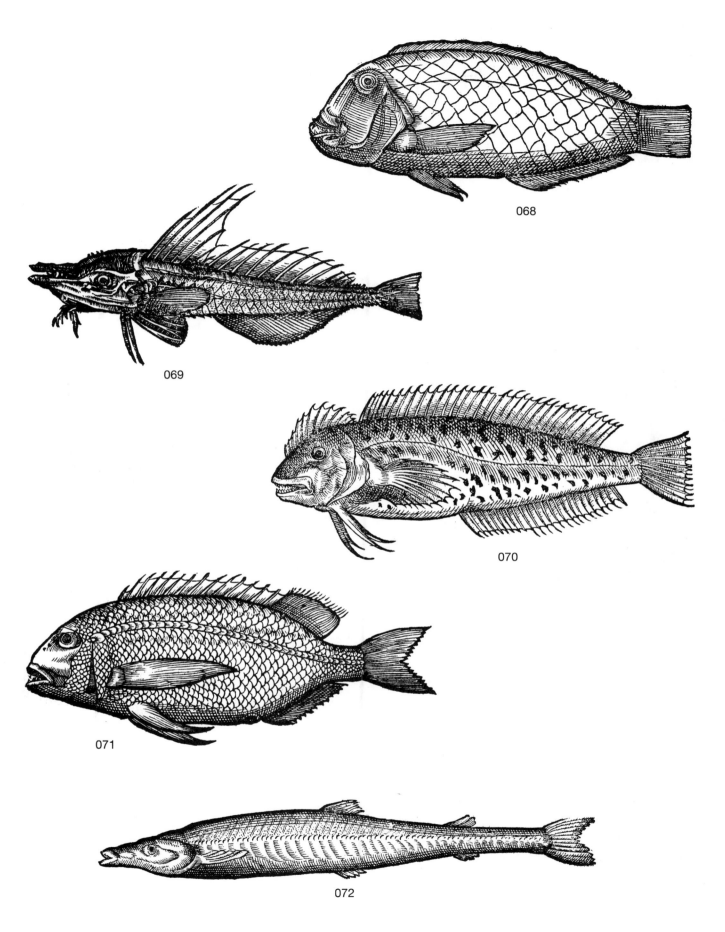

068

069

070

071

072

068. Razor fish. 069. A type of sea robin. 070. An unidentified fish of rocky shores (Latin, *exocoetus*).
071. Dentex (a type of sea bream). 072. Sand-eel or –launce.

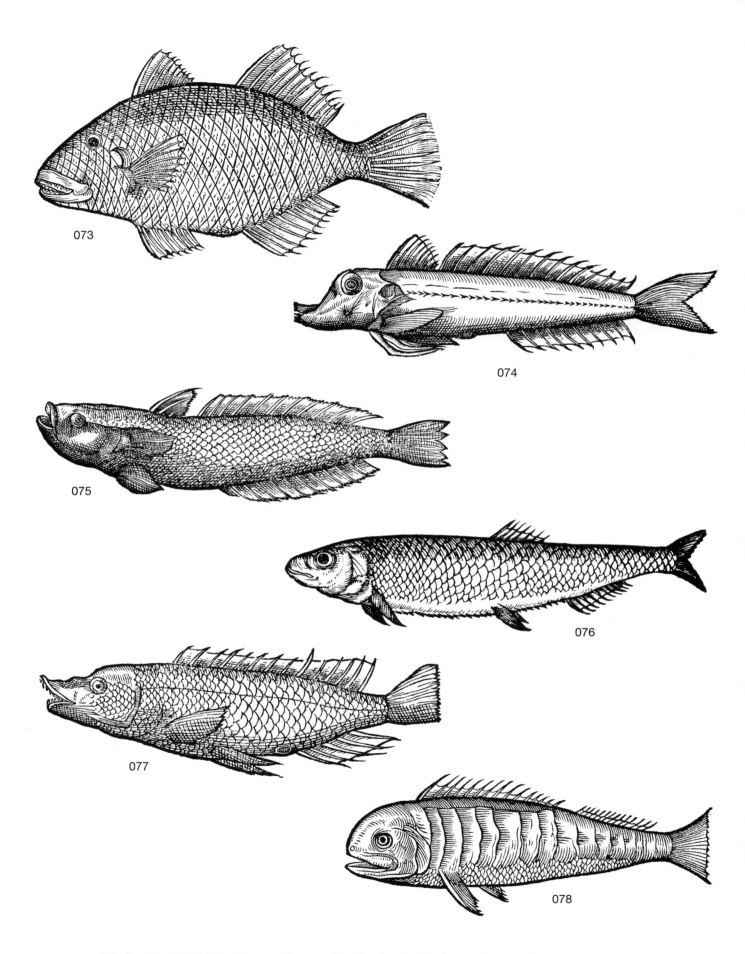

073. An identified fish (Latin, *aper,* German, *Geissbrachsme*). 074. A type of gurnard. 075. A type of goby. 076. Herring. 077. A type of wrasse. 078. An American trunkfish.

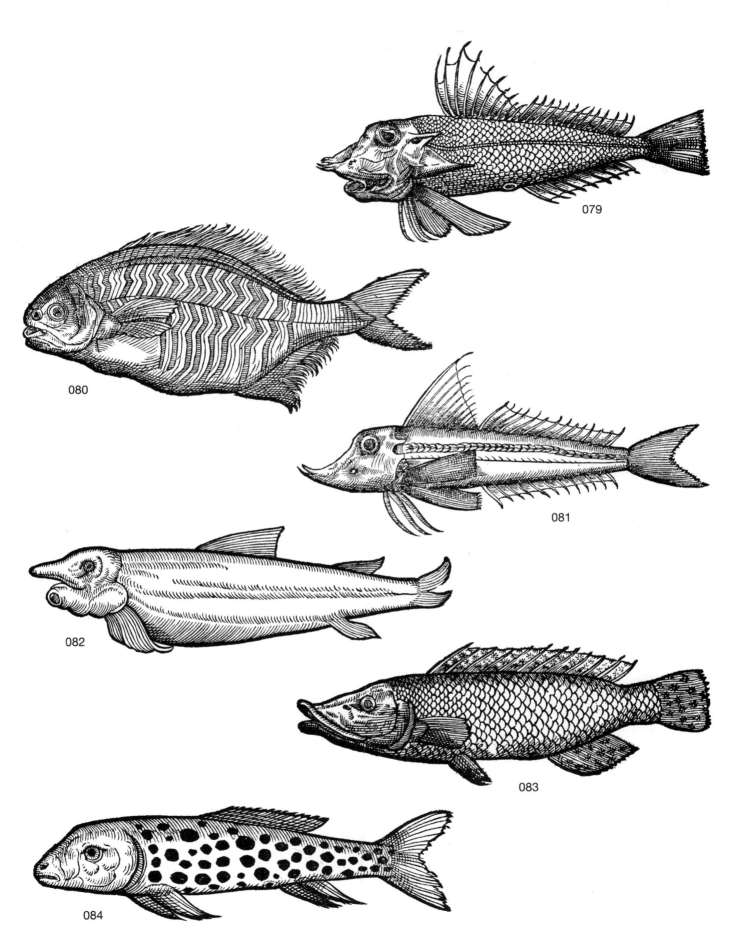

079. Sea robin. 080. An unidentified fish (Latin, *fiatola*). 081. Another member of the sea robin family. 082. Sturgeon. 083. A type of wrasse. 084. "A wonderful fish found near Lynne, England in 1555."

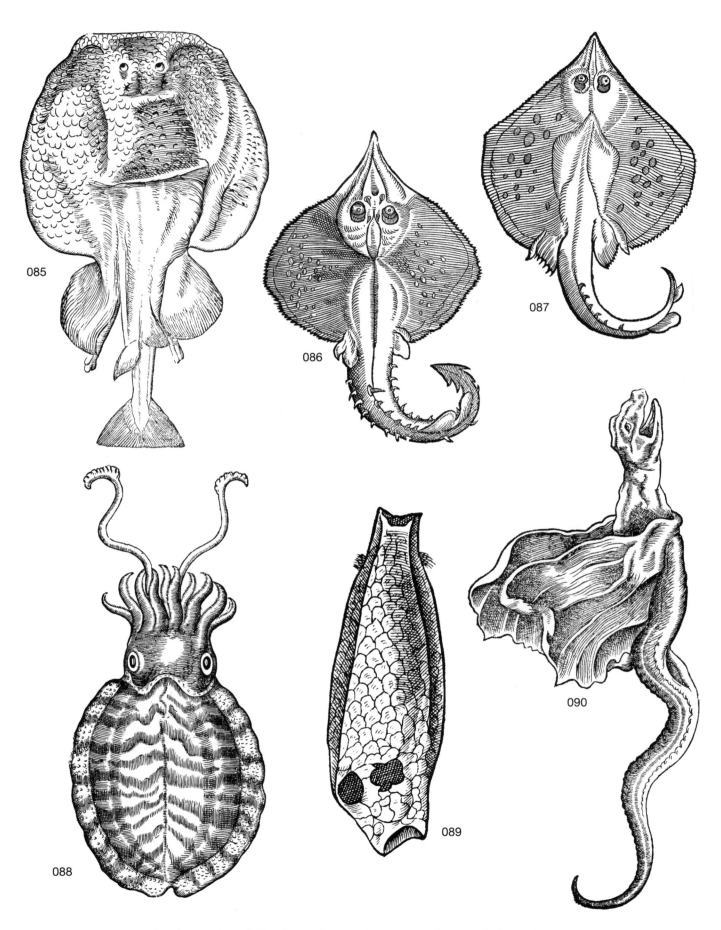

085. Electric ray. 086 and 087. Types of ray or skate. 088. Squid. 089. Skeleton of a trunkfish.
090. Jenny Haniver: a mutilated ray or skate.

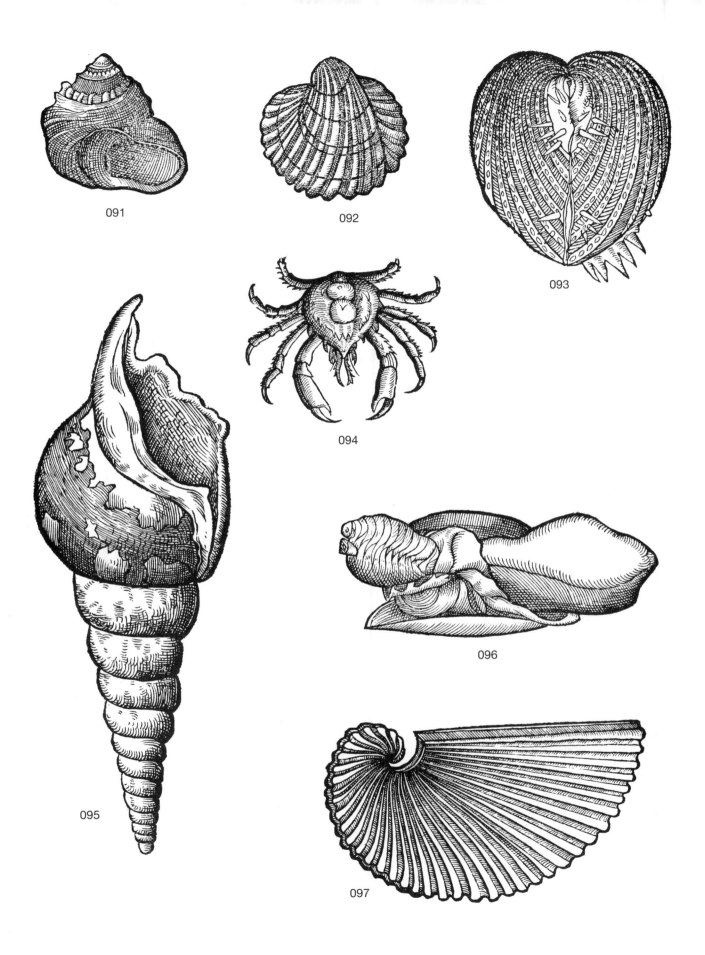

091. A type of sea snail. 092. A type of cockle. 093. Spiny cockle. 094. A type of crab.
095. A large sea snail, perhaps a triton. 096. A clam, showing internal organs. 097. Shell of paper nautilus.

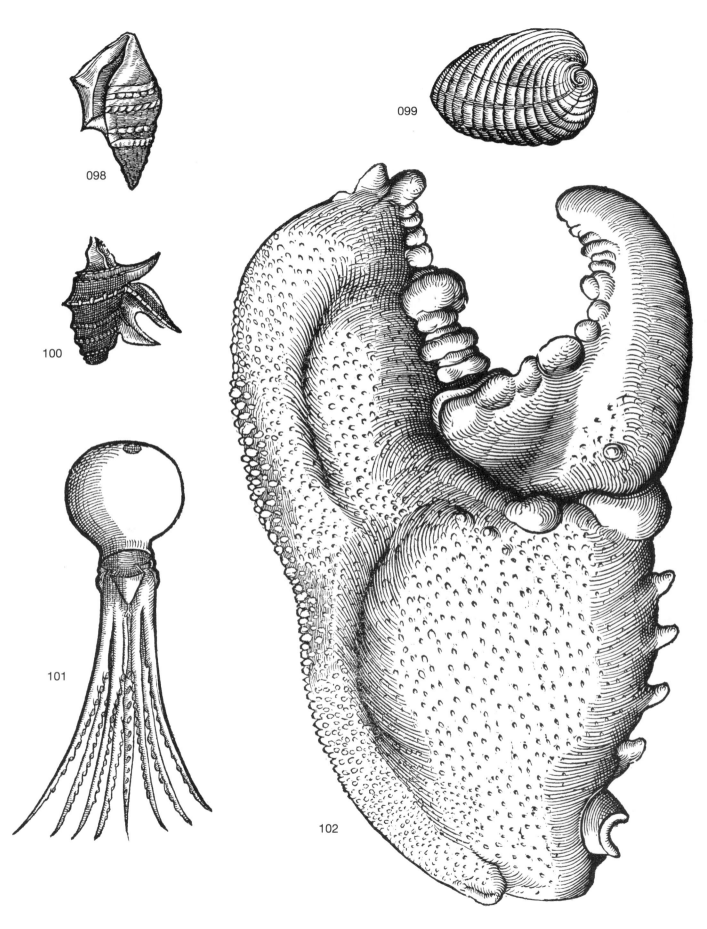

098. "Eared" sea snail. 099. A type of cockle. 100. Pelican's foot.
101. A type of octopus or squid. 102. Lobster claw.

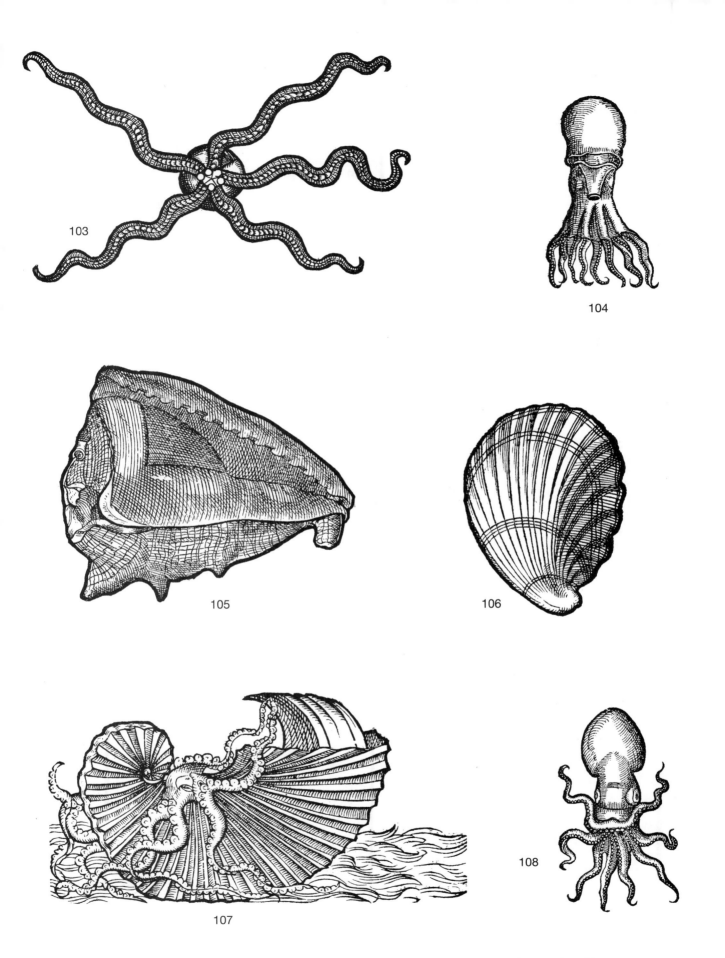

103. Serpent-star. 104. Octopus (back view) 105. A type of sea snail. 106. A type of cockle.
107. Paper nautilus. 108. Octopus (front view).

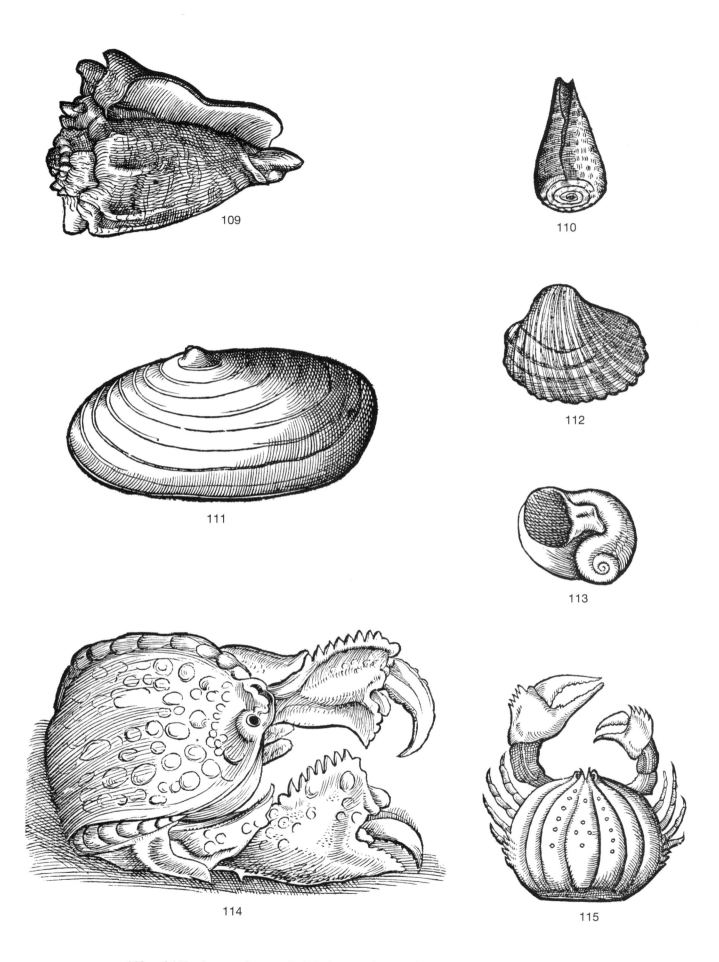

109 and 113. A type of sea snail. 110. A type of sea snail (perhaps an olive shell). 111. Clam.
112. A type of cockle. 114 and 115. A type of crab.

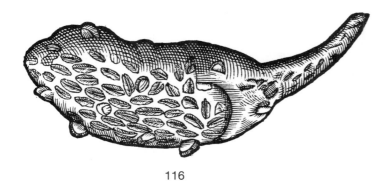

116

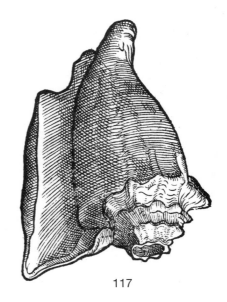

117

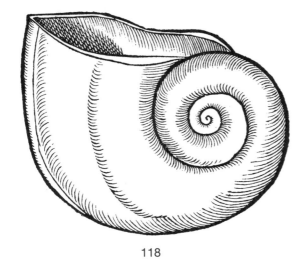

118

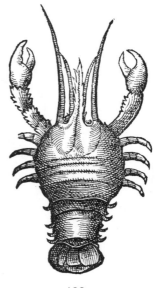

120

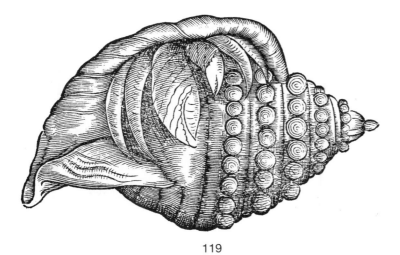

119

116. "Sea grape" (perhaps a sea slug). 117 and 118. A type of sea snail.
119. Hermit crab in a whelk shell. 120. A small marine crustacean.

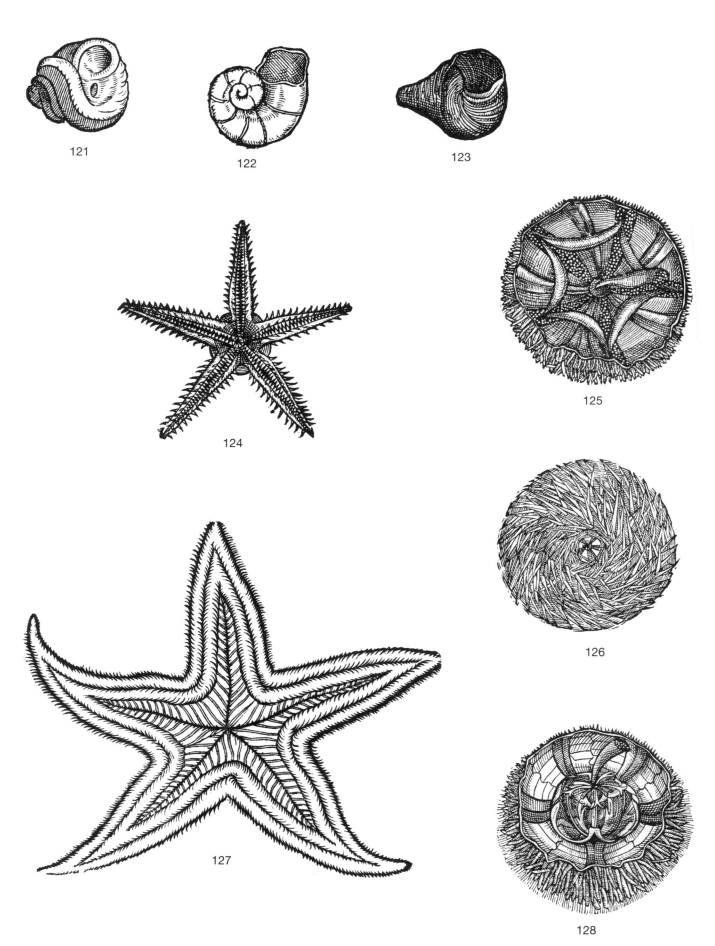

121–123. Sea snails. 124 and 127. Starfish. 125, 126, and 128. Sea urchins, two of them dissected.

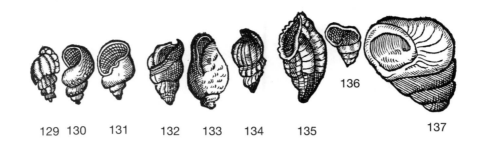

129 130 131 132 133 134 135 136 137

138

139

140

129–137. Various small sea snails. 138. Another view of the "sea grape." 139. Sea cucumber. 140. A type of crab.

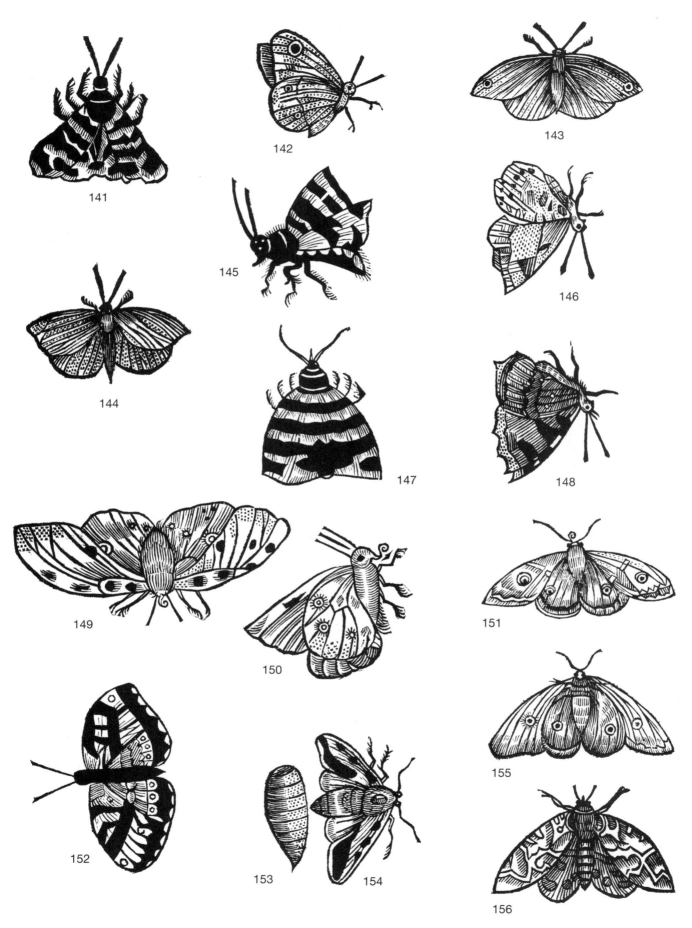

141–156. Various butterflies and moths (153. pupa).

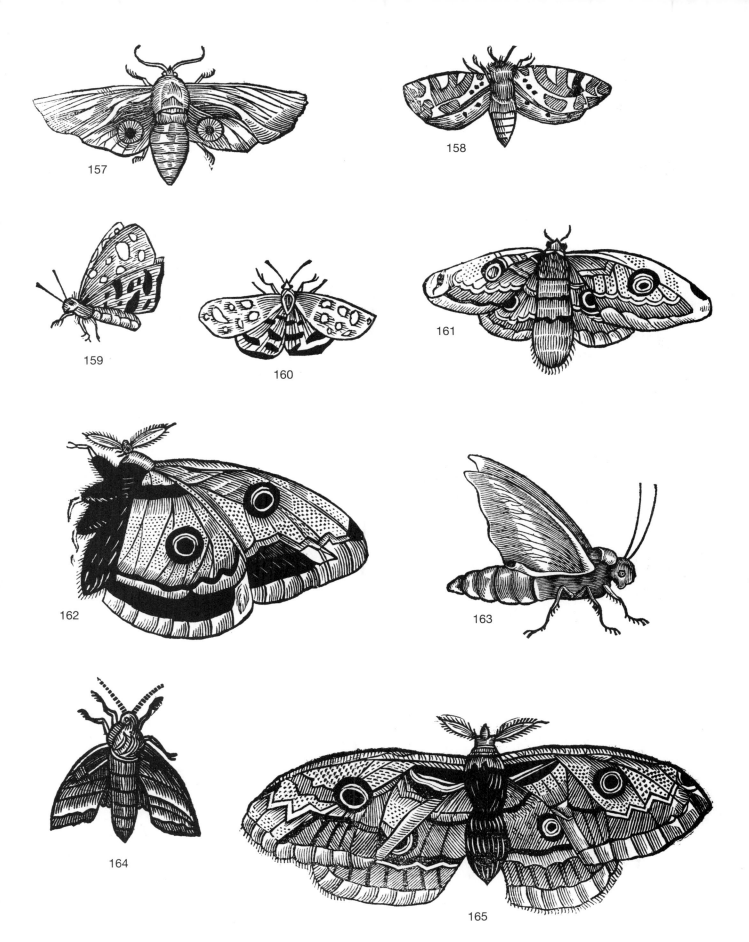

157–165. Various butterflies and moths.

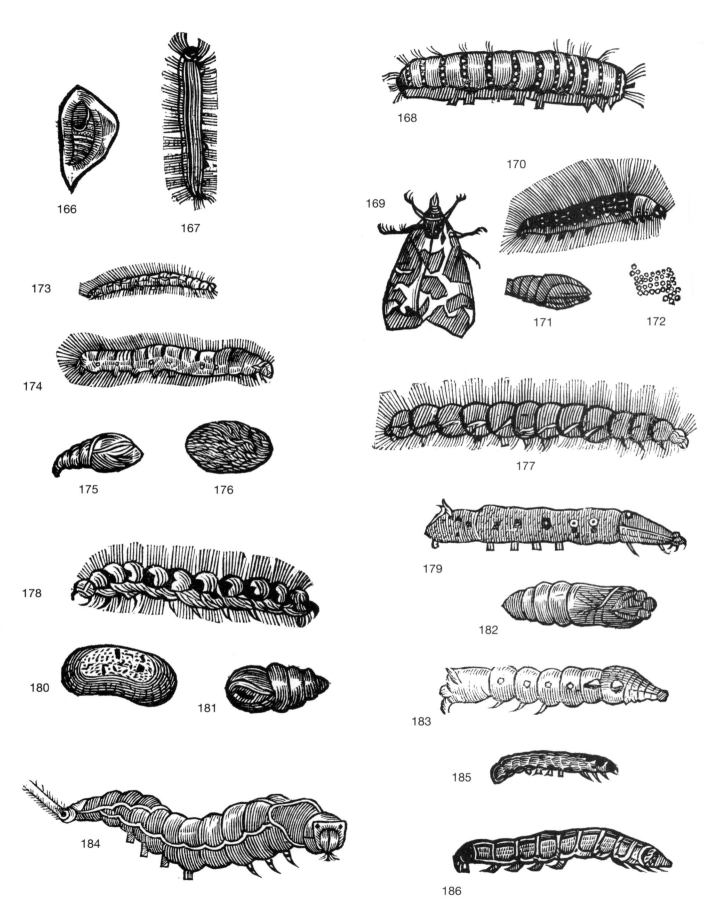

166, 171, 175, 176, 180-182. Pupae. 167, 173, 168, 170, 173, 174, 177-179,
183-186. Caterpillars or larvae. 169. A type of moth. 172. Moth eggs.

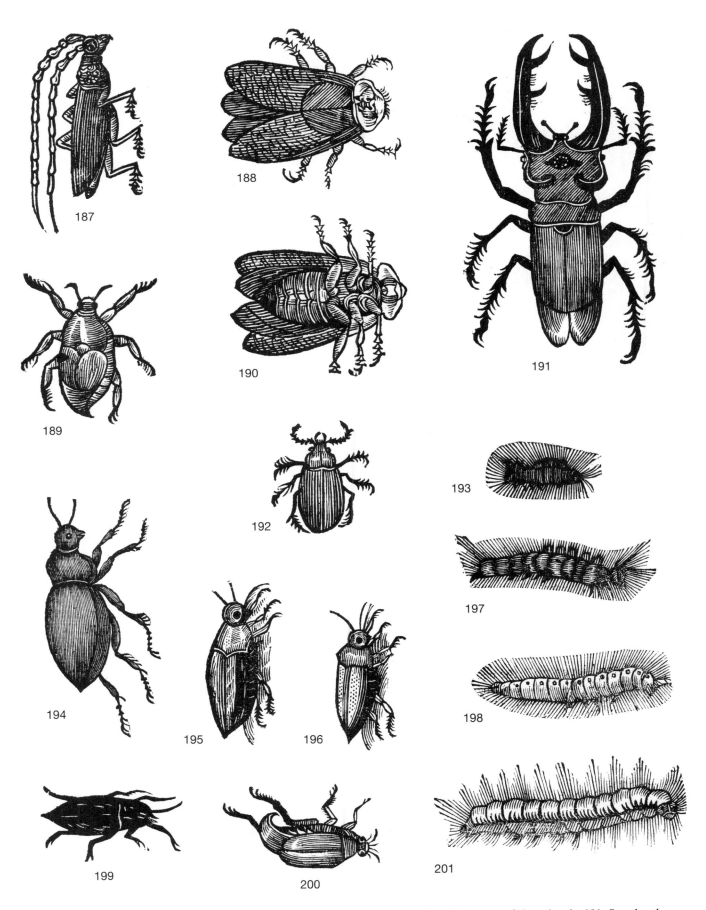

187. Longhorn or capricorn beetle. 188 and 190. Cicadas ("grasshoppers"). 189. A type of dung beetle. 191. Stag-beetle. 192, 195, and 196. Various beetles *(Melolonthe)*. 193,197,198, and 201. Various caterpillars. 194. A type of beetle from Constantinople. 199. Another type of beetle. 200. Dorbeetle (kin of the American June beetle).

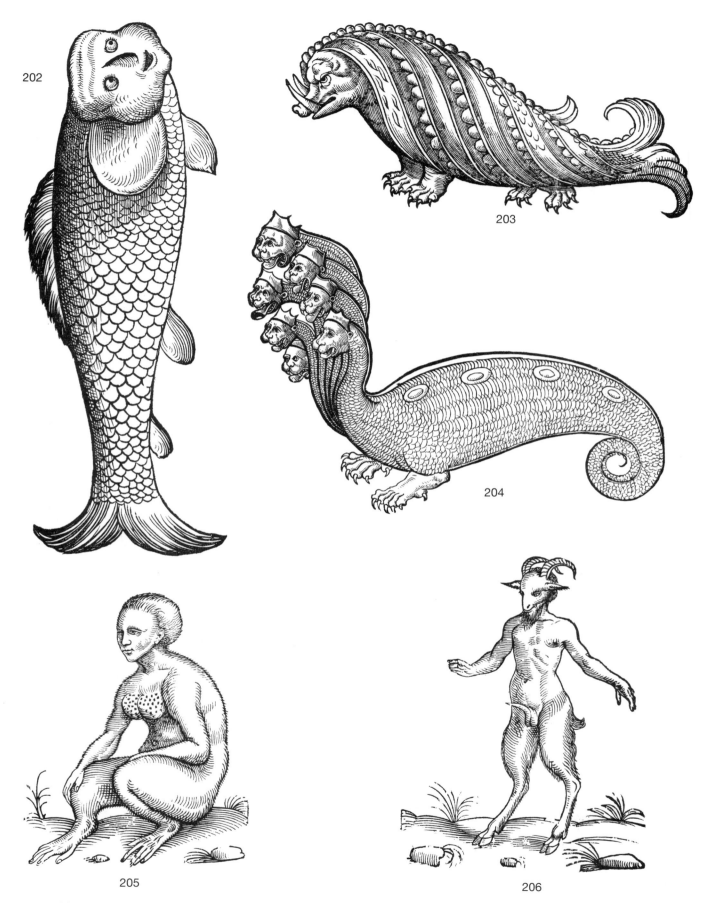

202. Carp or bream with human face, also regarded as a fanciful representation of the manatee. 203. "Boar whale" (Latin, *aper cetaceus*) as described by Olaus Magnus in his description of the northern seas. 204. Hydra. 205. Sphinx. 206. "Aegopithecus, an Ape like a Goat."

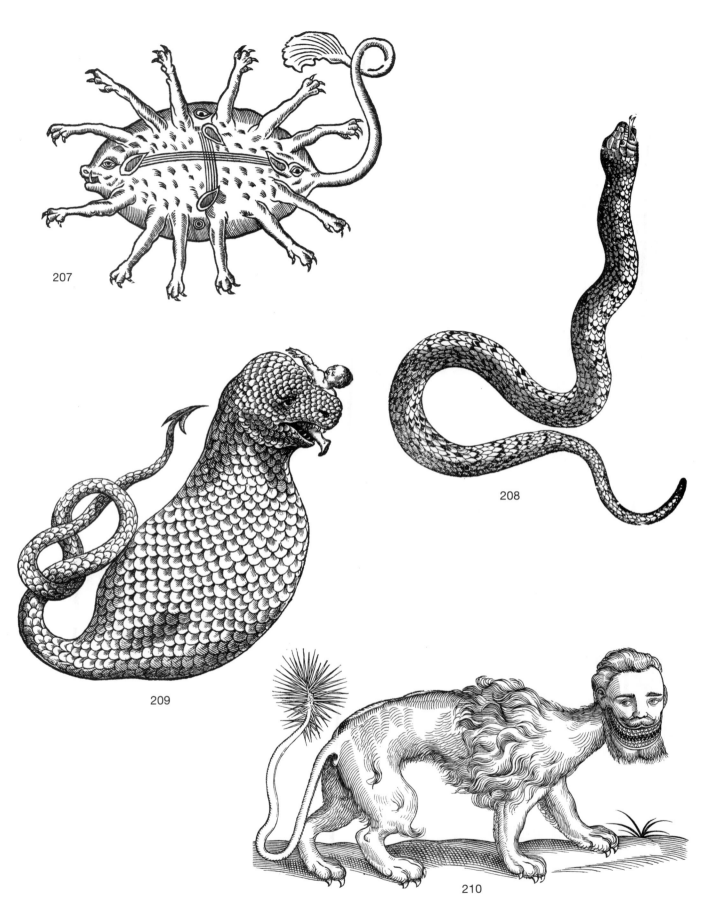

207. Sea creature sighted between Antibes and Nice in 1562. 208. A serpent.
209. Boa ("boas") devouring a child. 210. Manticore, or "mantichora."

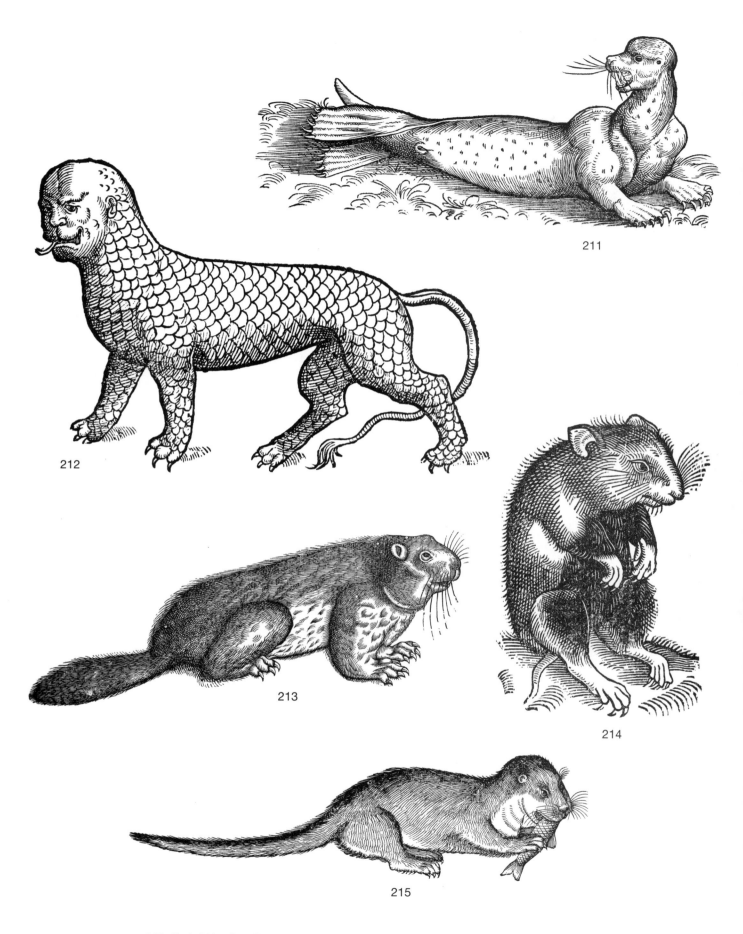

211. Seal. 212. Lion-like sea monster. 213. Water rat, or vole. 214. Hamster. 215. Otter.

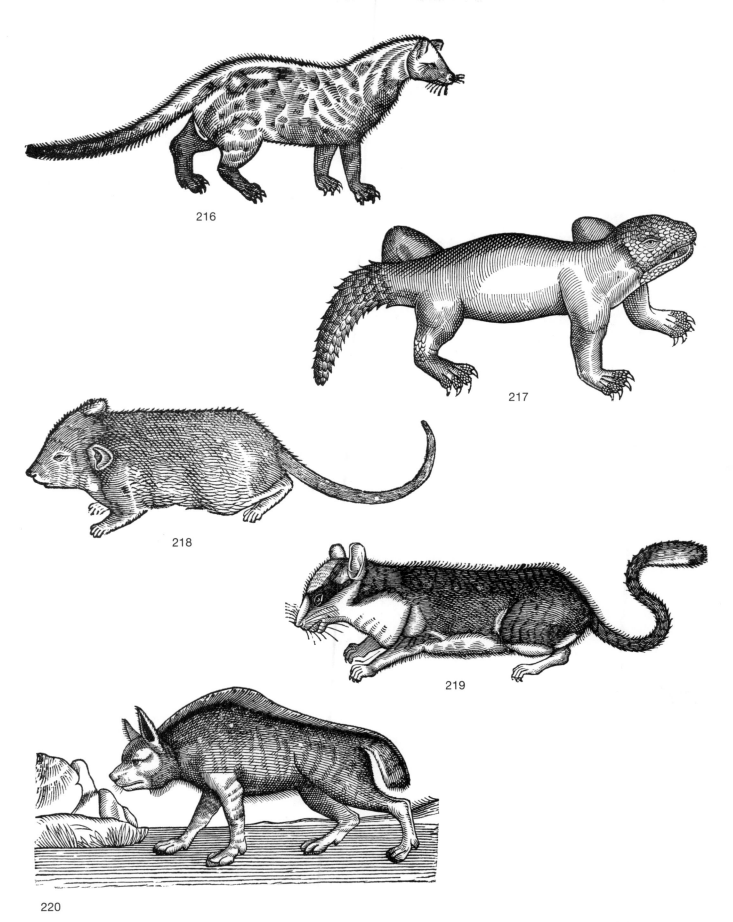

216. Civet cat, or "ziveth." 217. "Arabian or Egyptian land crocodile," probably a spiny-tailed agama of the mastigure group of lizards. 218. Mouse. 219. Common dormouse, or "nut-mouse, haselmouse, filbird-mouse." 220. "Sea wolf," which "liveth both on sea and land."

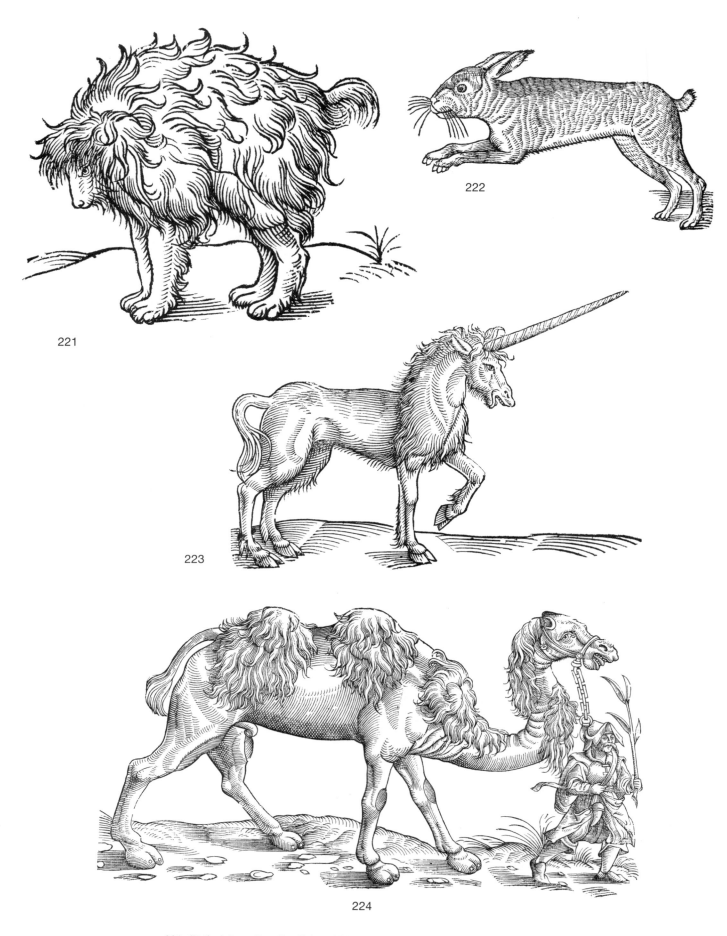

221. "Mimick or Getulian" dog. 222. Hare. 223. Unicorn. 224. Bactrian camel.

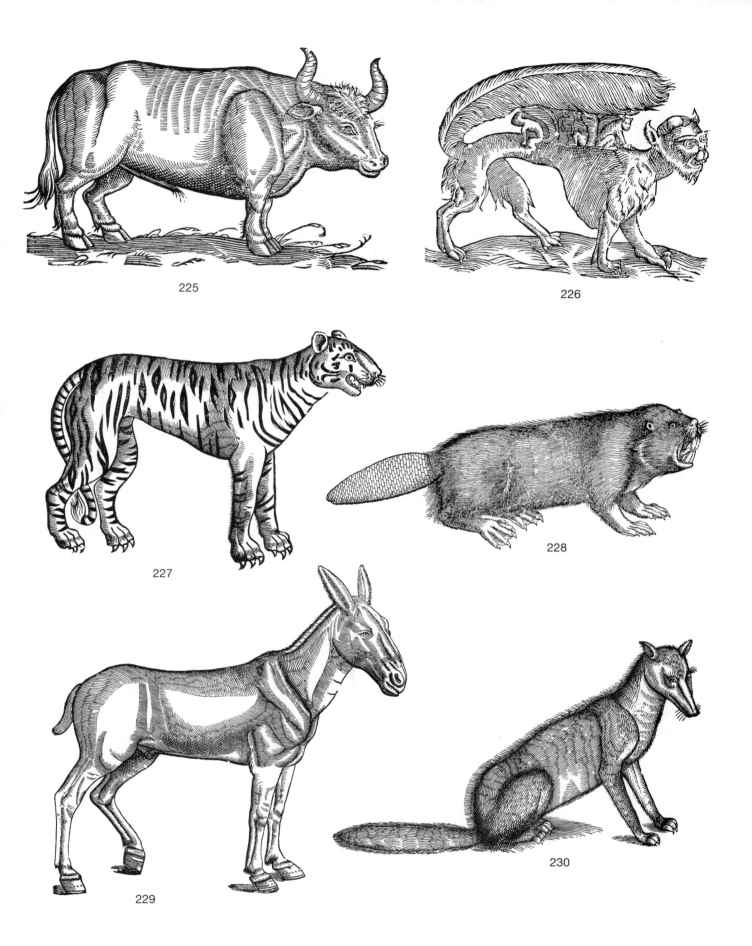

225. Aurochs, or "ure-ox." 226. "Su," a fierce animal hunted for its skin in Patagonia. 227. Tiger. 228. Beaver. 229. Mule. 230. Fox.

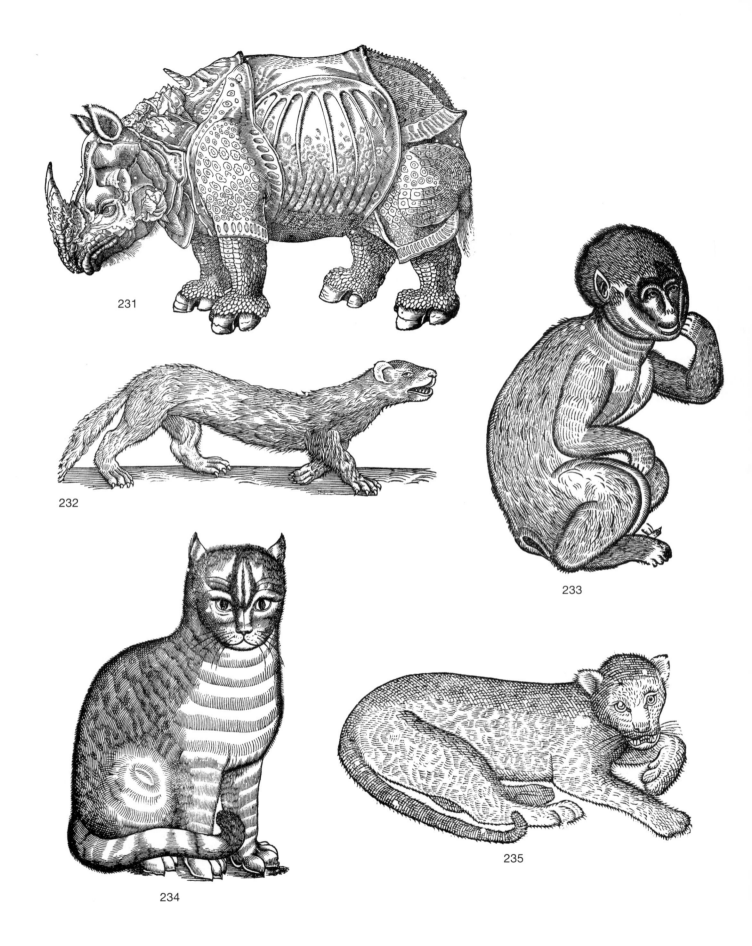

231. Rhinoceros. 232. Polecat, or "fitch." 233. Ape. 234. Cat.
235. "Ounce," an African leopard, not the snow leopard.

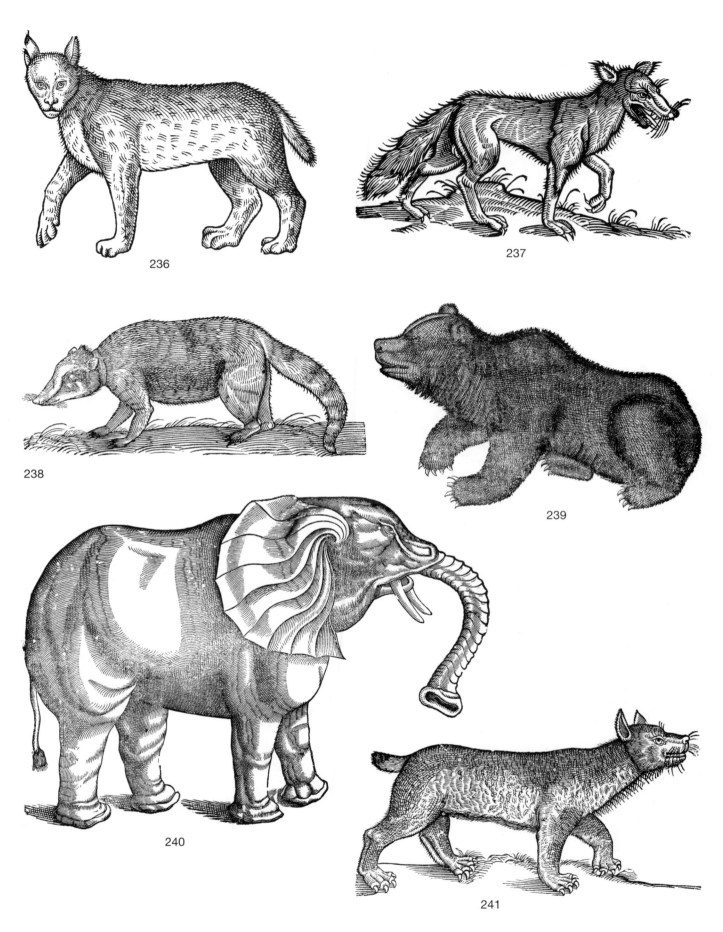

236 and 241. Lynx. 237. Wolf. 238. "Sorex," probably an animal of the raccoon or weasel family. 239. Bear. 240. Elephant.

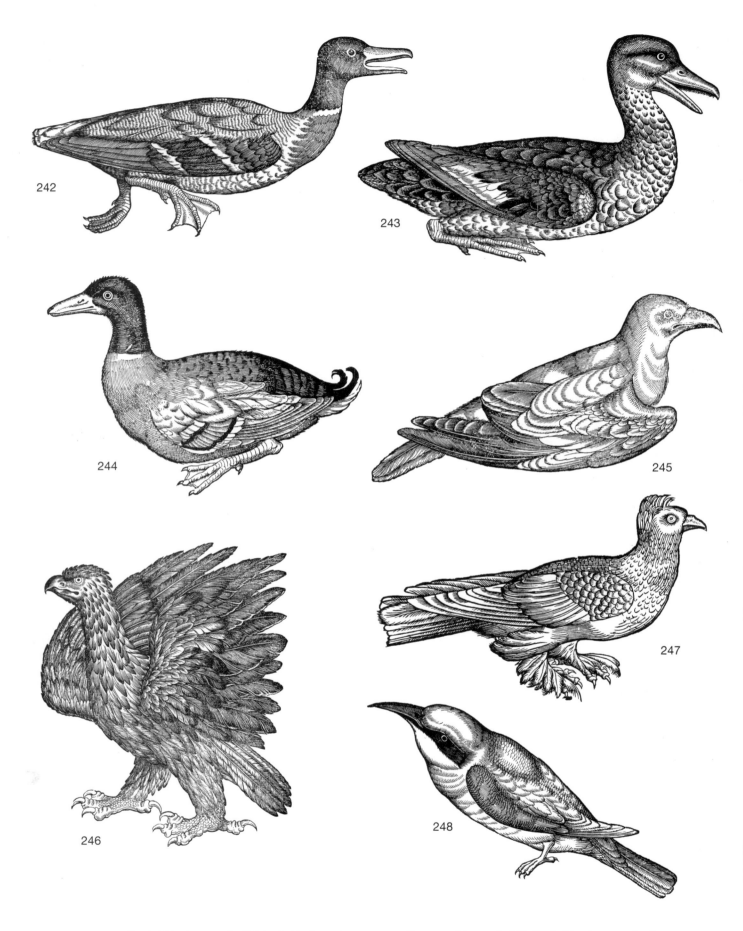

242. Mallard. 243. A type of wild duck (Latin, *anas muscaria*; German, *Muggent*). 244. Probably also a mallard. 245. Roller. 246. Golden eagle. 247. Domesticated pigeon. 248. Perhaps a bee-eater.

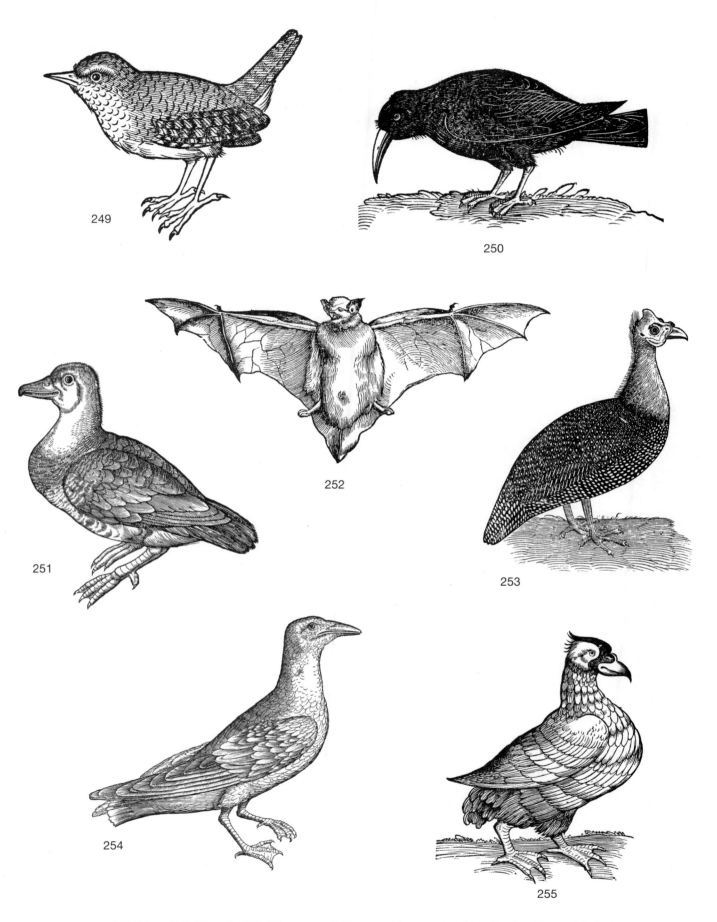

249. Wren. 250. Chough. 251. "Tree goose," (German, *Baumgans*), said to live in willows. 252. Bat. 253. Common guinea-fowl. 254. A type of gull. 255. Capercaillie.

37

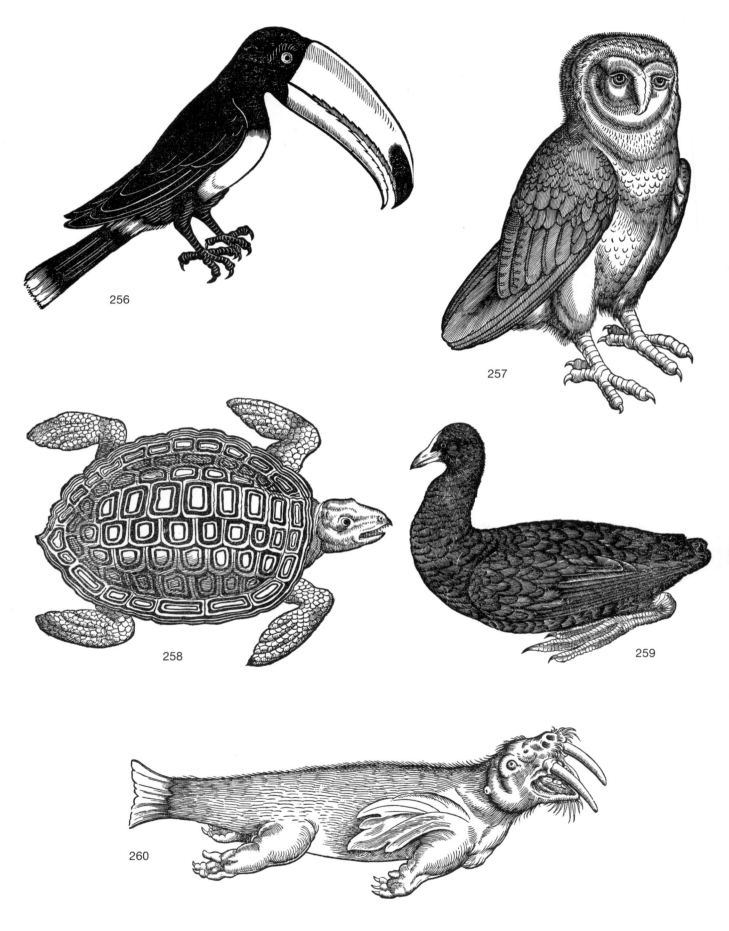

256. Toucan. 257. An owl, perhaps the barn owl. 258. A type of marine turtle. 259. Coot. 260. Walrus.

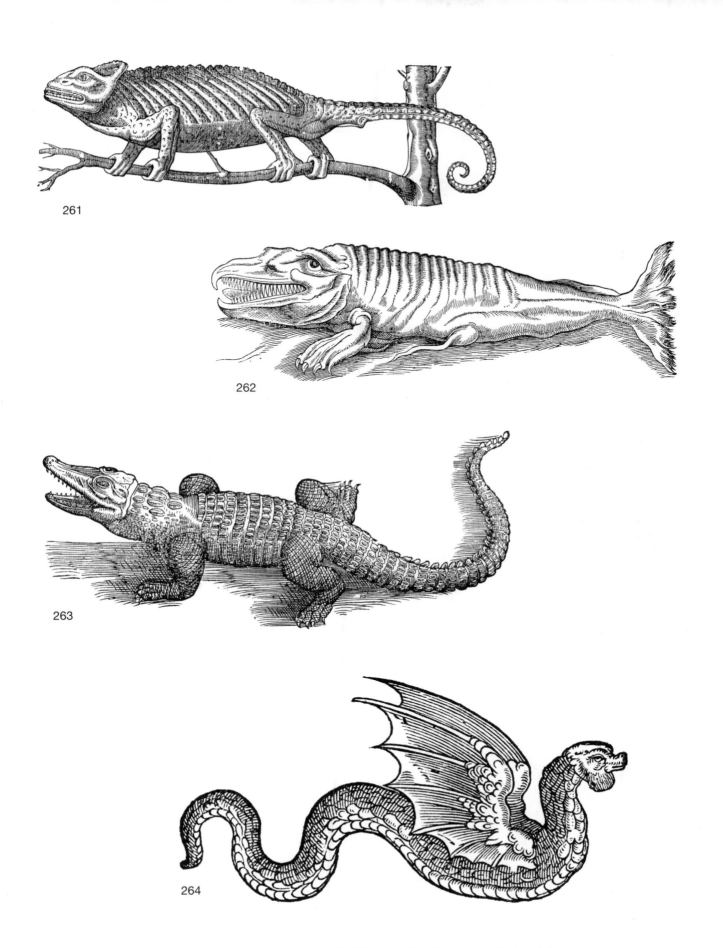

261. Chameleon. 262. A whale. 263. Nile crocodile. 264. A type of winged dragon.

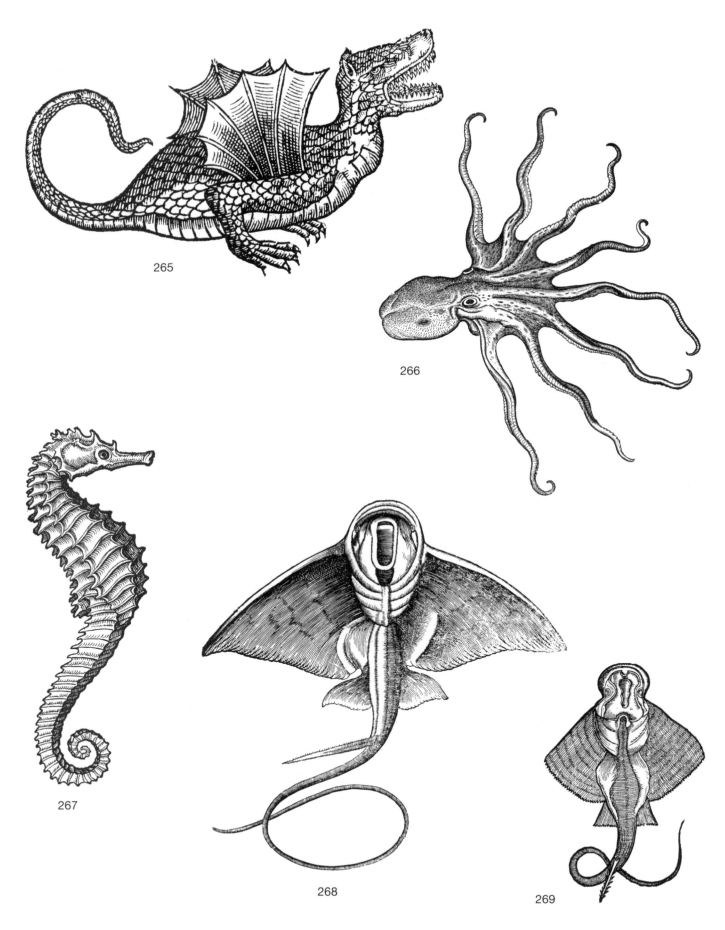

265. A type of winged dragon. 266. Octopus. 267. Seahorse.
268. A ray, perhaps an eagle ray or stingray. 269. Another type of ray.

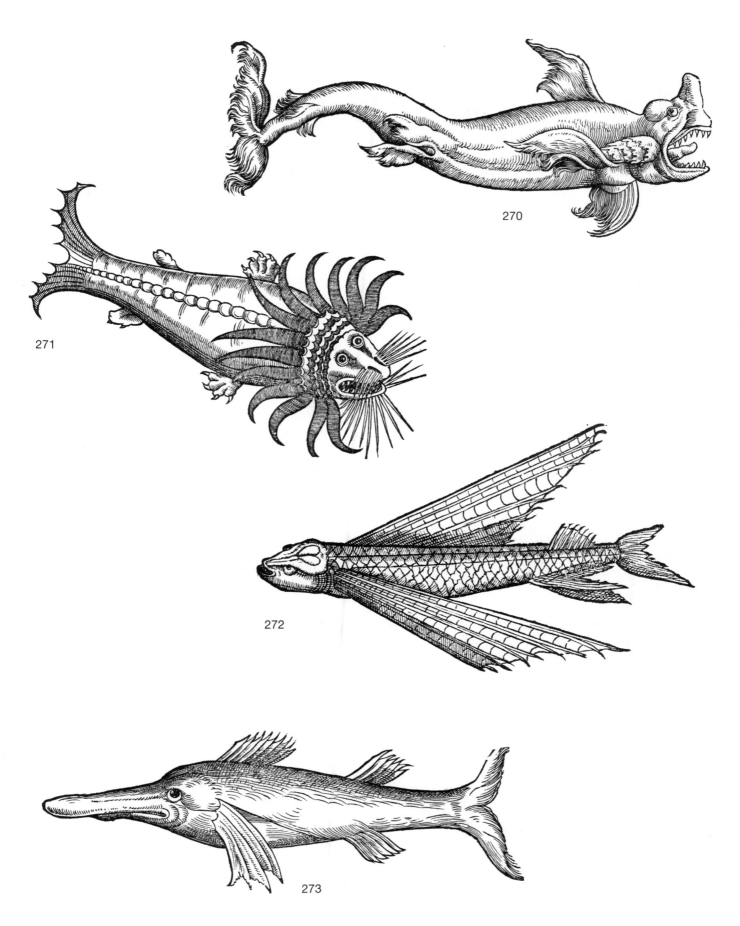

270. "Dephin." 271. "Bearded whale" reported by Olaus Magnus. 272. Flying gurnard or flyingfish. 273. Swordfish.

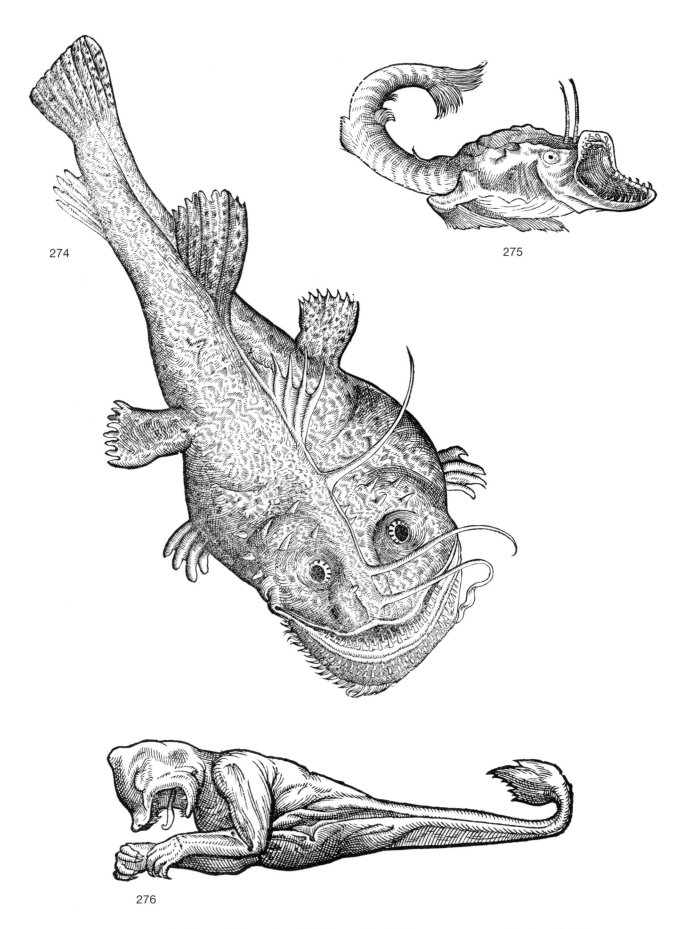

274 and 275. Two depictions of the angler. 276. Picture of an Indian serpent supposedly found in Milan, published by Gesner on the authority of Cardano.

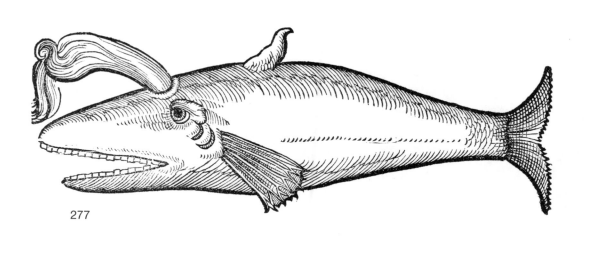

277

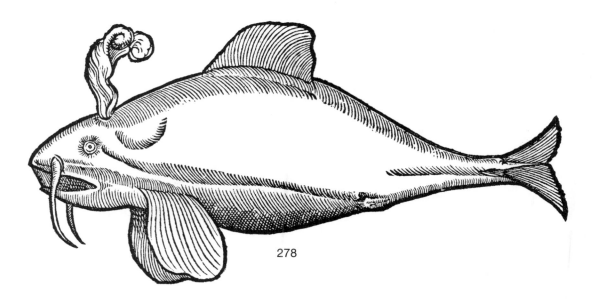

278

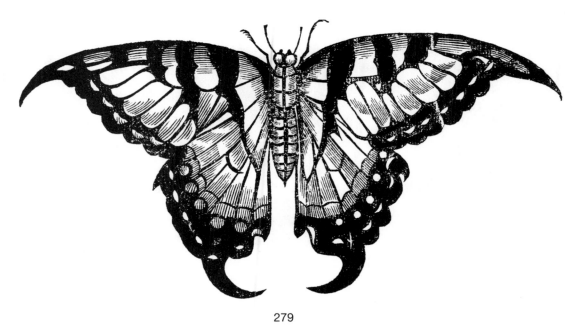

279

277. A type of whale; Gesner himself found the reconstruction unsatisfactory.
278. Probably a type of small whale. 279. A swallowtail butterfly.

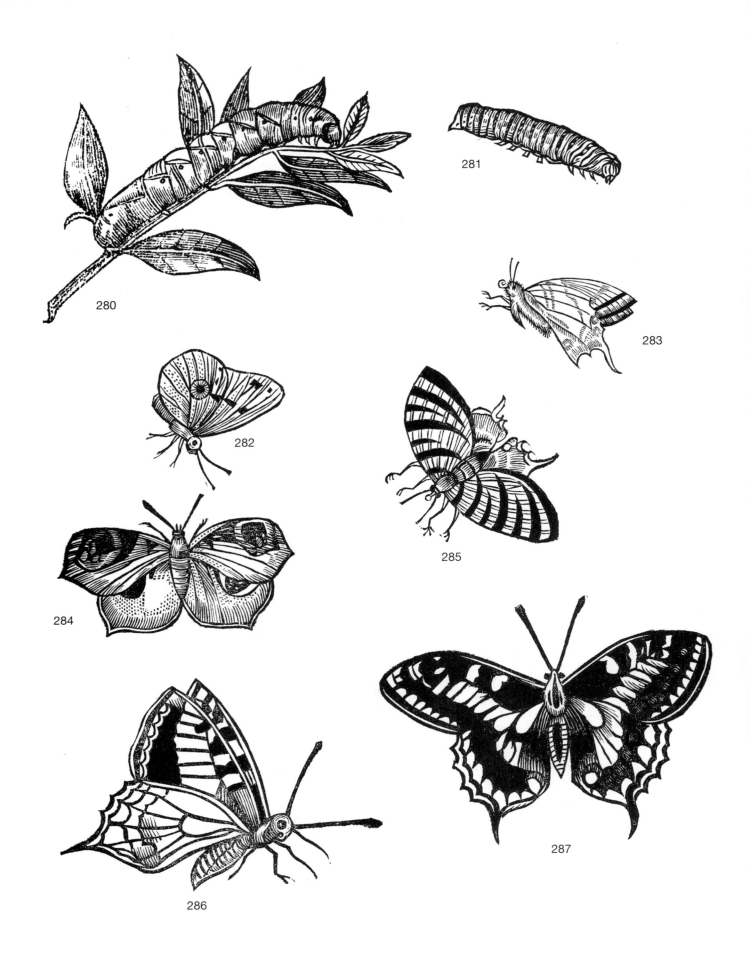

280–287. Caterpillars and butterflies.

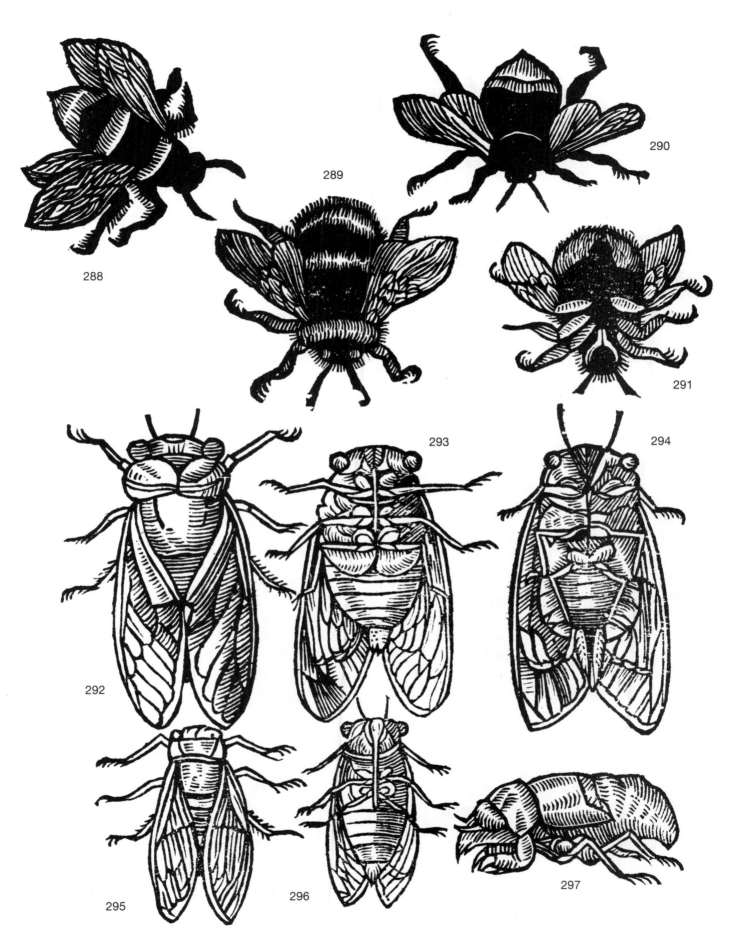

288–291. Bumblebees. 292–297. Cicadas or flies and a bug or beetle.

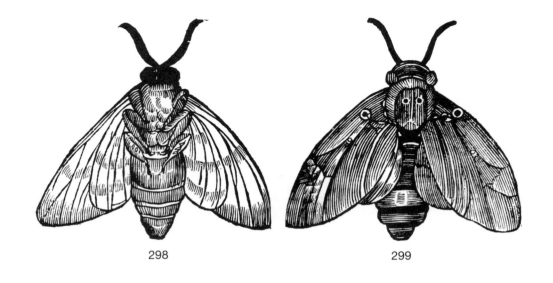

298 299

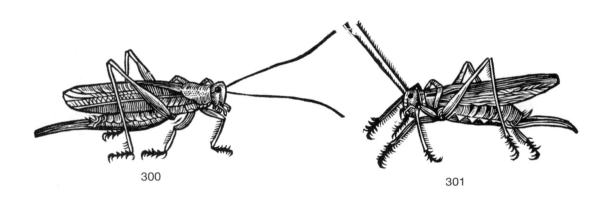

300 301

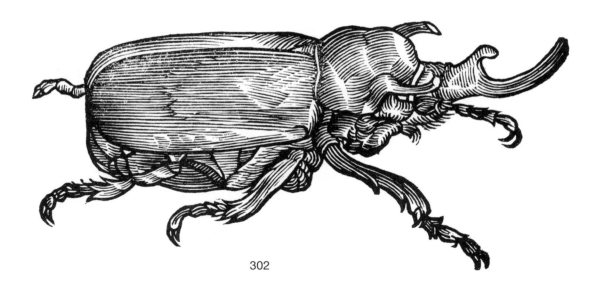

302

298 and 299. Moths. 300 and 301. Locusts. 302. Rhinoceros beetle, or "nose-horn."

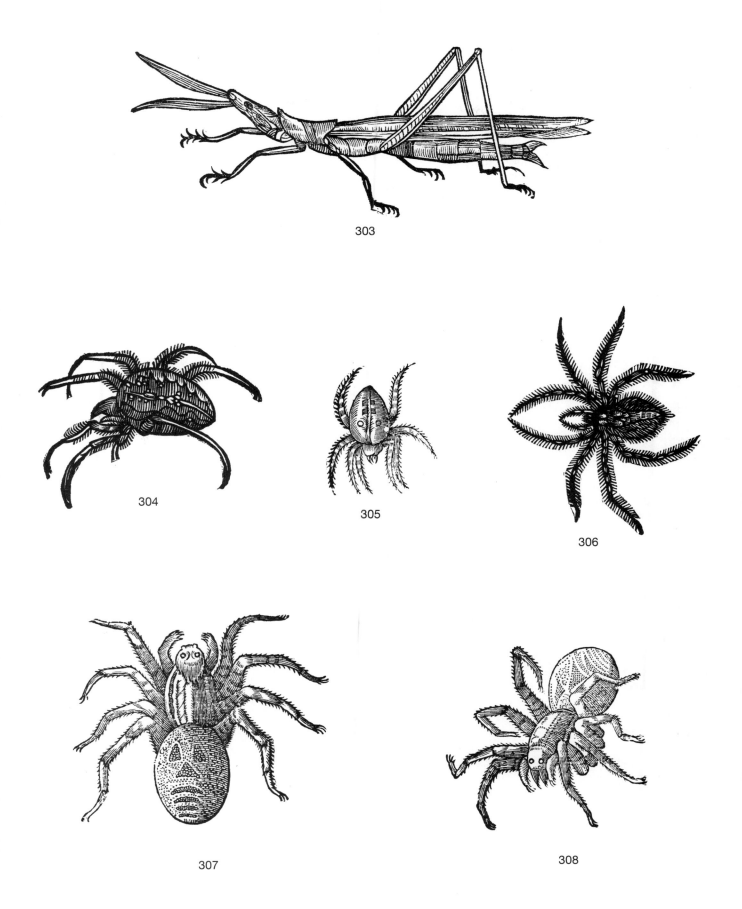

303. A grasshopper or mantis from North Africa. 304–308. A variety of spiders.

INDEX